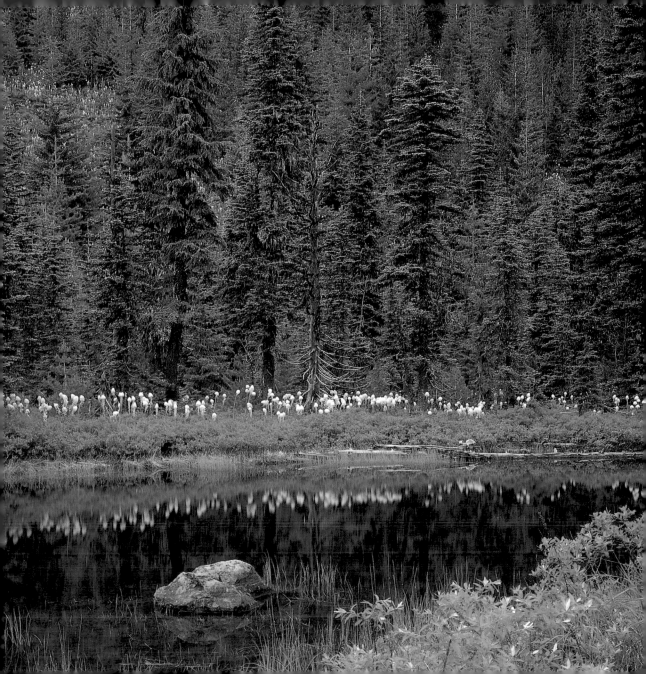

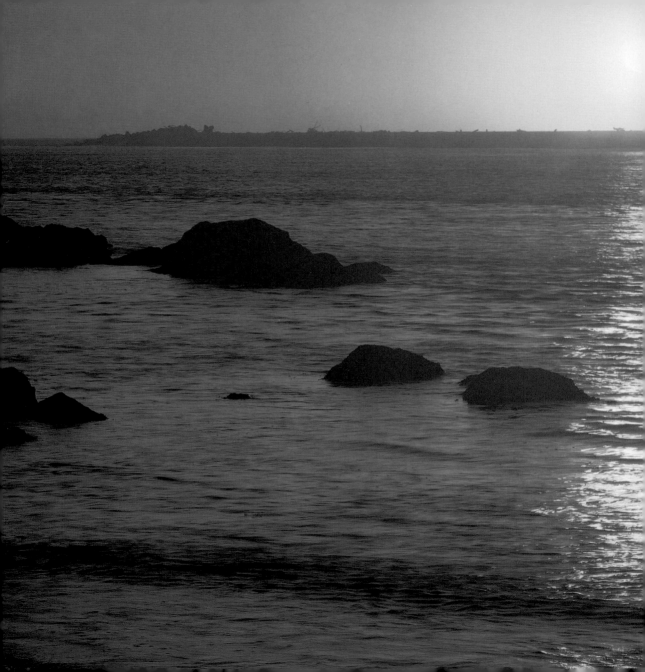

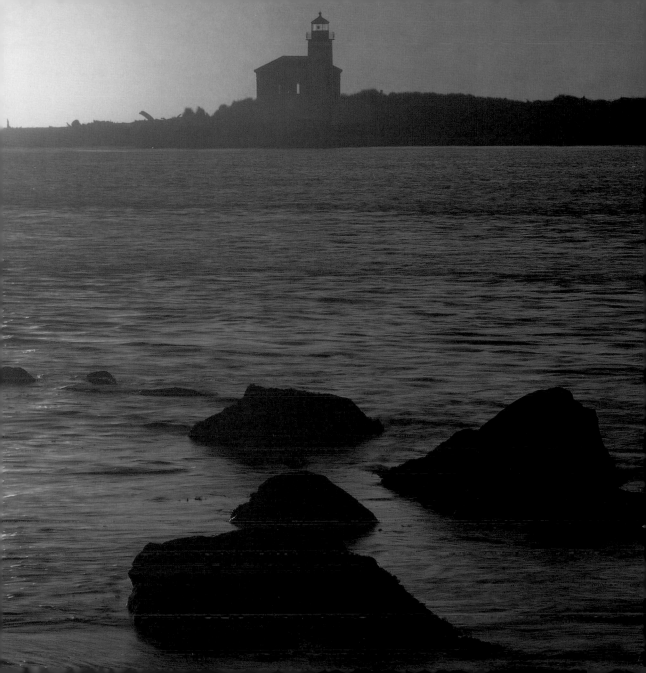

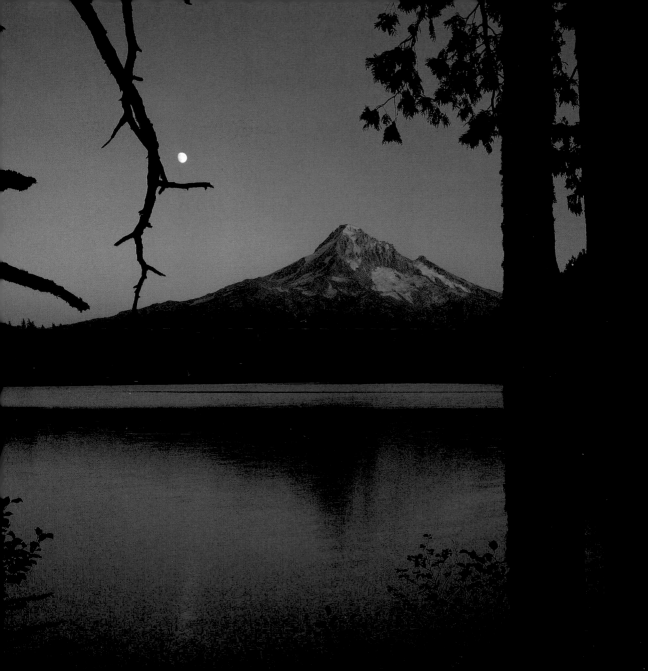

OREGON REFLECTIONS

Photography by Steve Terrill
With Selected Prose & Poetry

1585-A FOLSOM STREET, SAN FRANCISCO, CALIFORNIA 94103
TEL: 415-522-1680 FAX: 415-626-1510
email: ecopress@ecocorps.org
Website: www.owplaza.com/mandala

First frontispiece: Eureka Lake, Mount Hood National Forest
Second frontispiece: Coquille River Lighthouse, Bandon
Third frontispiece: Mount Hood, above Lost Lake
Opposite: Rippled reflection of maple trees in the North Umpqua River

❧

International Standard Book Number: 1-56579-146-0
Library of Congress Catalog Number: 95-62435
Copyright Steve Terrill, 1996. All rights reserved.
Published by Westcliffe Publishers, Inc.
2650 South Zuni Street, Englewood, Colorado 80110
Publisher, John Fielder; Editor, Suzanne Venino; Designer, Amy Duenkel
Printed in Hong Kong by Palace Press International

This is a Special Edition for EcoCorps Press
1585-A Folsom Street, San Francisco, California 94103
415.522.1680 Fax: 415.626.1510
E-Mail: ecopress@ecocorps.org
Website: www.owplaza.com/mandala

Ecocorps wishes to express its gratitude to John Fielder
for giving his generous support in the publishing of this EcoPress edition.

In recognition of our shared responsibility to preserve the environment
Palace Press International will plant two trees to replace every tree
that was harvested to produce the paper to make this book.

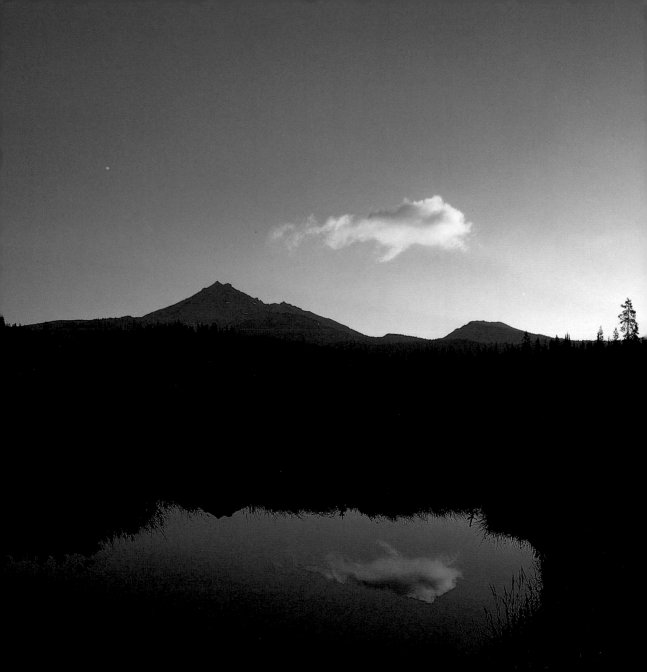

PREFACE

There is a calm yet untamed beauty to Oregon which is clearly captured by the photography of Steve Terrill in this special EcoCorps edition of *Oregon Reflections*. Underlying that calm there is a battle raging. It is the fight between the conservationists, the politicians and the lumber industry. The battlefield is Oregon's dwindling old growth forests, rivers, streams and wetlands. The casualties are many.

This is the state where billboards once widely read, "Welcome to Oregon, Now Go Home," and another sign dubbed a clear-cut forest the "James Watt Scenic Wayside," jabbing the government official who allowed the wholesale destruction to take place. The signs of thoughtful resistance to environmental degradation are still evident in Oregon and hopefully they will prevail in the struggle to keep their wilderness sacred.

When we look at the images herein we should understand them as the real measure of wealth in any society. To sacrifice our air, water, food, natural beauty, and open space in the name of pursuing a higher standard of living is suicidal. As Thoreau questioned, "What is the use of a house without a tolerable world to build it on?" Yet America's natural heritage—old-growth forests, pristine lakes and streams, rich and vast farmlands, abundant and diverse wildlife—is being destroyed even as we view the photographs in this book.

Oregon writer James David Duncan describes a fishing expedition to the Washogal river:

"There is a Gangian majesty to the lower Columbia, and something awesome, if not holy, in knowing its currents are made of glaciers, springs, desert seeps... But when I turned, as I had known I must, to the third waterway, things immediately began to break down. I knew that a creek named Lacamas—a genuine little river—entered the Crown Zellerbach mill on the opposite side from us.

But the mill-used fluid that shot from the flume just downstream bore no resemblance to water. It looked like hot pancake batter, gushing forth in a quantity so vast that part of me found it laughable. But it was a steaming, poisonous, killing joke that shot across the Woshugal's drought-shriveled mouth in a yellow-gray scythe, curved downstream and coated the Columbia's north shore with what looked like dead human skin for miles."

James David Duncan-River Teeth

It is not enough to capture images of beauty on film and enjoy it vicariously through books. It is time to put into place permanent conservation movements if there is to be anything left of our natural environment.

EcoCorps wants to make environmental awareness part of everyone's daily thinking. Before purchasing a product we should ask, "How will this effect the earth?" When we vote we should consider, "Will this person contribute to the preservation or destruction of the envi-

Broken Top Mountain, Deschutes National Forest

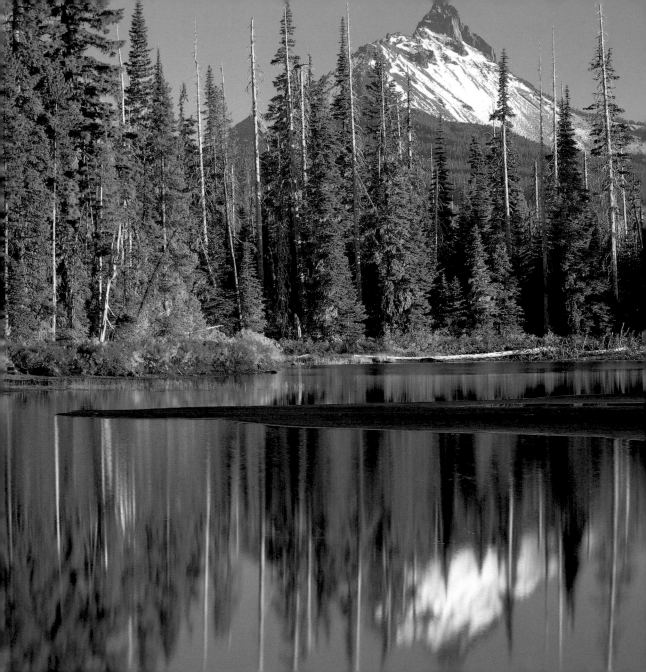

ronment?" Before doing business, we should question, "What is this company's environmental track record?" And we should ask ourselves how our diet and lifestyle affect the natural world. Unless we all start asking these questions and answering them honestly, our natural resources will vanish.

Consumption has become the measure of success and the Earth is paying the price. EcoCorps believes that ecological consciousness must become an inseparable part of American culture. To promote environmental awareness, EcoCorps is involved in numerous projects. Ocean Song Farm and Wilderness Center serves as an organic farm, environmental education center, wilderness preserve and retreat facility. Located on 340 acres in the coastal hills of California's Sonoma County, Ocean Song is a practical example of sustainable living.

To restore and preserve one of Hawaii's most precious coastal areas, EcoCorps is developing the Waipio Valley Arboretum, a 42-acre arboretum and ecocultural garden retreat on the Hamakua Coast. Alternative agricultural techniques such as organic gardening, bamboo cultivation, and permaculture are employed and are the topics of seminars and field training. A museum of cultural history in Waipio Valley and a Hamakua orientation center will serve as community support facilities. The arboretum and garden will feature indigenous tropicals and endangered exotic species of plants. Cultural gardens and structures will showcase traditions of sound ecological stewardship.

In India, EcoCorps is restoring and preserving damaged ecosystems, ancient shrines, and historic architectural sites. By publishing books, creating video documentaries, and working with individuals and organizations, EcoCorps is informing people worldwide of the critical issues that are affecting the culture and environment of the people of India.

In order to direct purchasing to environmentally responsible products and services we have formed the Green Consumer Co-op a clearinghouse of earth-friendly products. EcoCorps is also distributing literature and audio/visual materials at schools and other public places, as well as conducting workshops and seminars on topics ranging from strawbale construction to vegetarian cooking. By organizing grassroots campaigns EcoCorps is keeping people informed of environmental issues and offering practical solutions to the problems we face.

Join EcoCorps in its battle to enlighten and preserve.

Jill Tabler, Director, EcoCorps

EcoCorps
1585 A Folsom Street, San Francisco, CA 94103
Tel: (415) 522-1680 Fax: (415) 626-1510
email: ecopress@ecocorps.org

Autumn colors along Big Lake, beneath Mount Washington,
Willamette National Forest

"Everybody needs beauty as well as bread,
places to play in and pray in where Nature
may heal and cheer and give strength to
the body and soul alike."

— John Muir, *Travels in Alaska*

Boats at sunset, Rooster Rock State Park,
Columbia River Gorge National Scenic Area

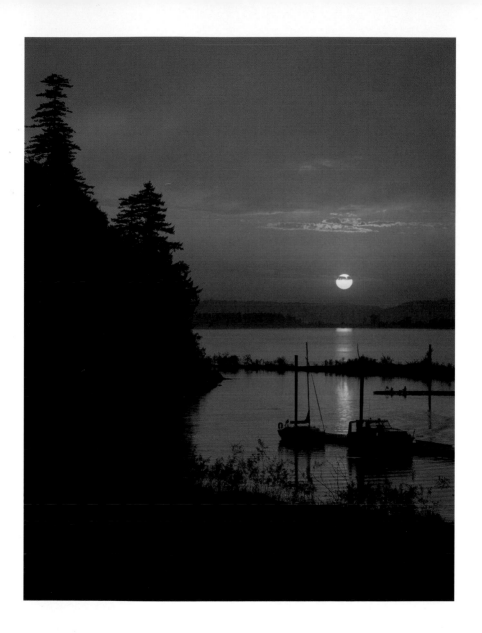

"How often we forget all time, when lone
Admiring Nature's universal throne
Her woods, her wilds, her waters intense
Reply of hers to our intelligence."

— Lord Byron, *The Island*

Mount Hood reflected in Lost Lake, Mount Hood National Forest

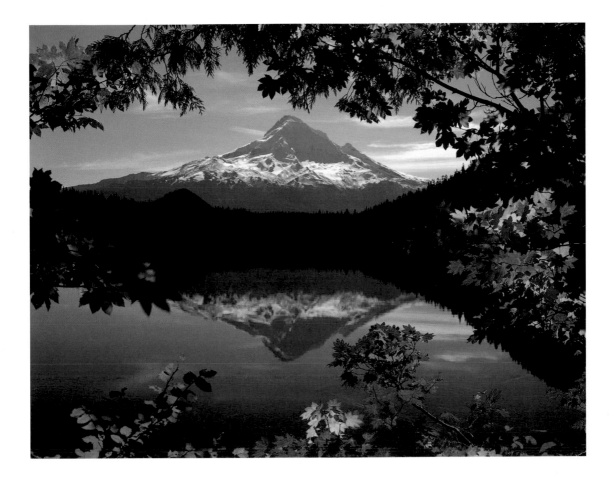

"Surely there is something in the unruffled calm of nature that overawes our little anxieties and doubts; the sight of the deep-blue sky...seems to impart a quiet to the mind."

— Jonathan Edwards,
The New Dictionary of Thoughts

Autumn along Donner und Blitzen River,
Malheur National Wildlife Refuge

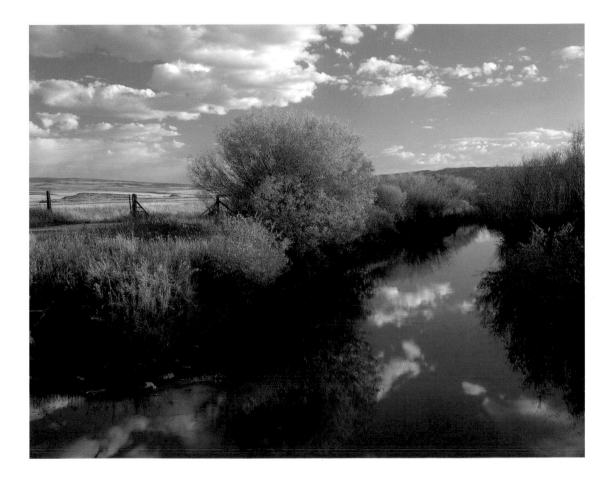

"The whole secret of the study of nature lies in learning how to use one's eyes...."

— George Sand, *Nouvelles Lettres d'un Voyageur*

Clouds mirrored in Benson Lake,
Columbia River Gorge National Scenic Area

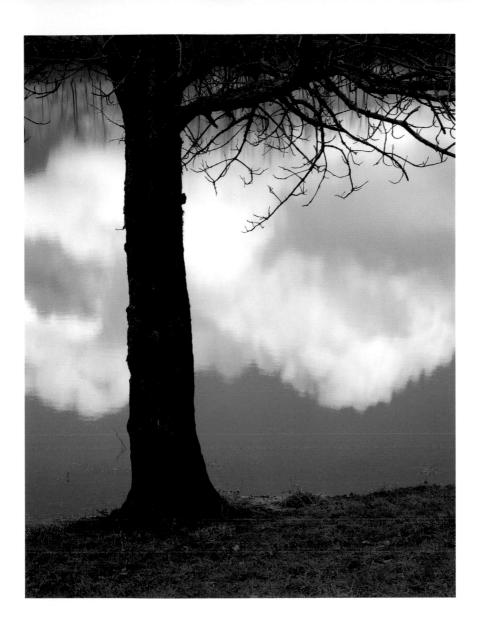

"...far off I watch the waterfall plunge to the long
river, flying waters descending straight...
till I think the Milky Way has tumbled from the
ninth height of heaven."

— Li Po, *Viewing the Waterfall at Mount Lu*

Youngs River Cascade, Clatsop County

Overleaf: Mount McLoughlin above Upper Klamath Lake, Klamath County

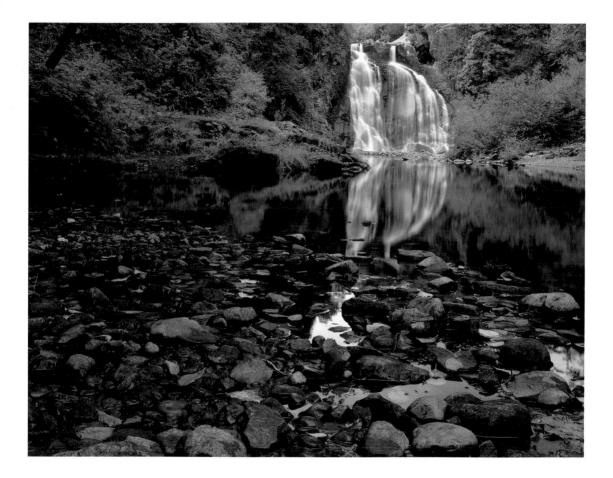

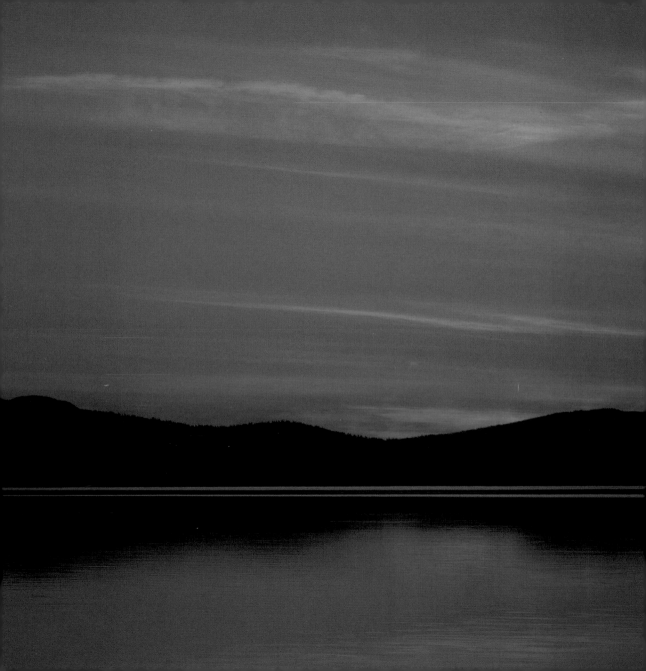

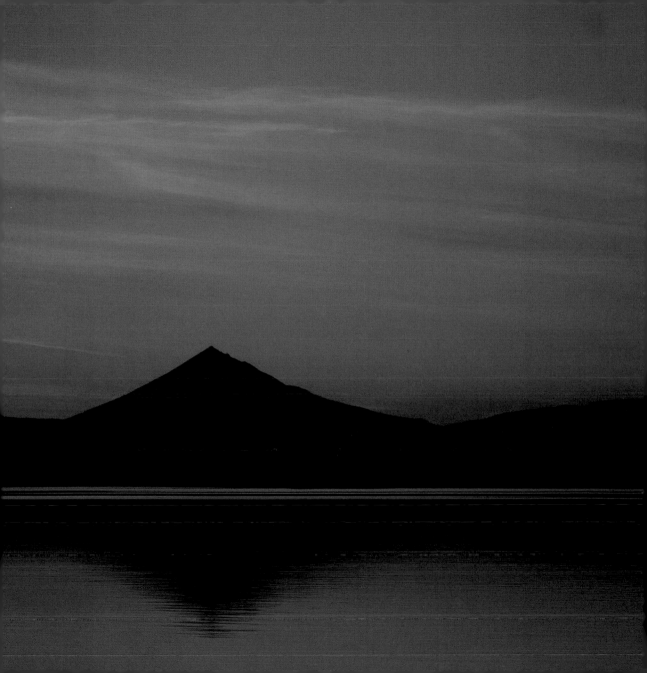

"Trees are the earth's endless effort
to speak to the listening heaven."

—Rabindranath Tagore, *Fireflies*

Summit Lake at sunrise,
Oregon Cascades Recreation Area

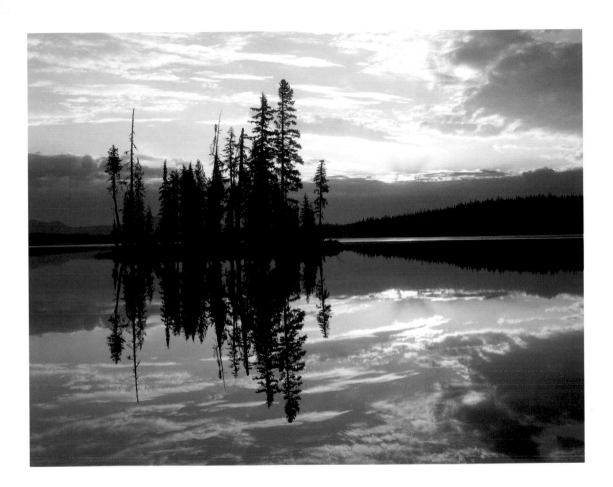

"There is a road from the eye to the heart
that does not go through the intellect."

— G. K. Chesterton, *The Defendant*

Silhouette of Vista House on Crown Point,
Columbia River Gorge National Scenic Area

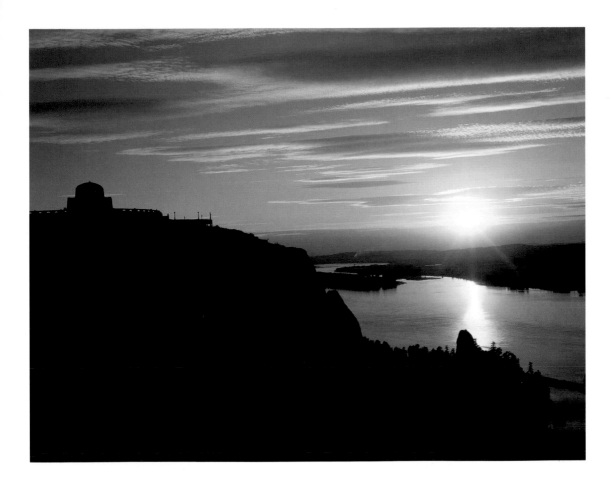

"In Nature's infinite book of secrecy,
A little I can read."

— Shakespeare, *Antony and Cleopatra*

Grasses and Oregon ash, Washington County

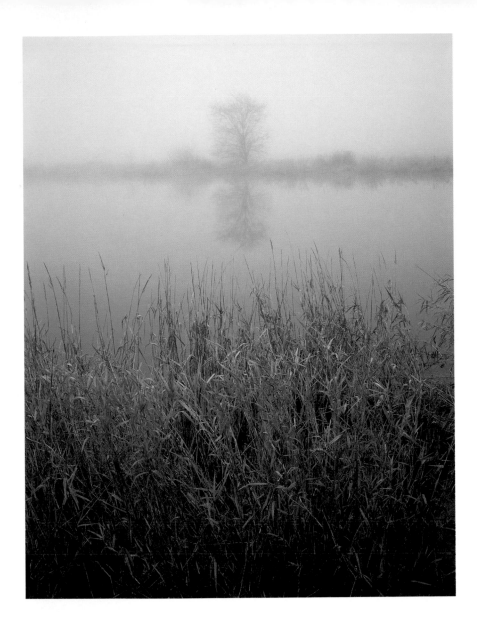

"Every situation — nay, every moment — is of
infinite worth, for it is the representative
of a whole eternity."

— Goethe, in Eckermann's *Conversations*

Sunrise at Wizard Island, Crater Lake National Park

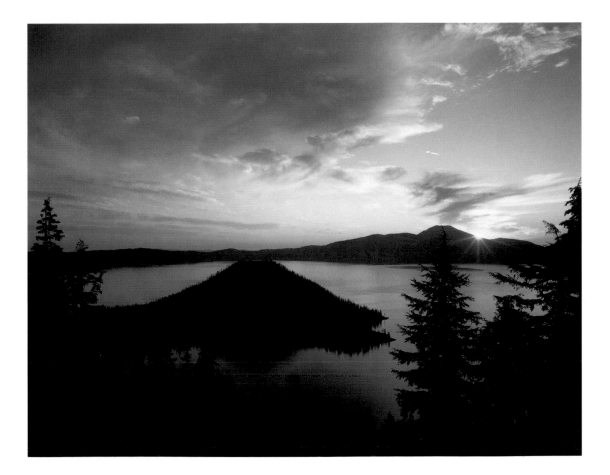

"Nature has presented us with a large faculty of entertaining ourselves alone...to teach us that we owe ourselves in part to society, but chiefly and mostly to ourselves."

— Montaigne, *On Giving the Lie*

Fishing boats, Yaquina Bay, Newport

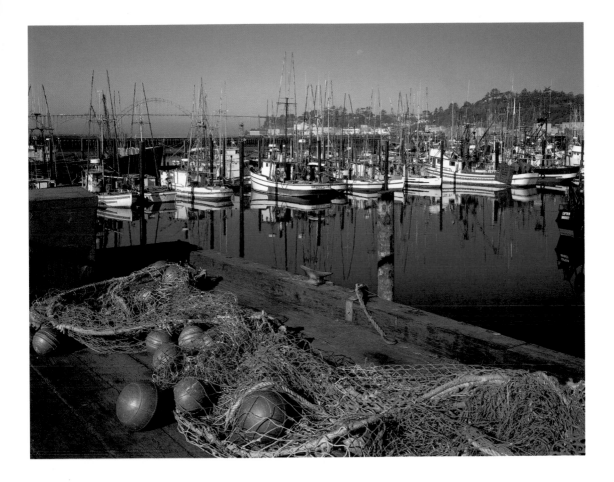

"It is the marriage of the soul with Nature that
makes the intellect fruitful, and gives birth
to the imagination."

— Henry David Thoreau, *Journal*

Eagle Cap reflected in Moccasin Lake, Eagle Cap Wilderness

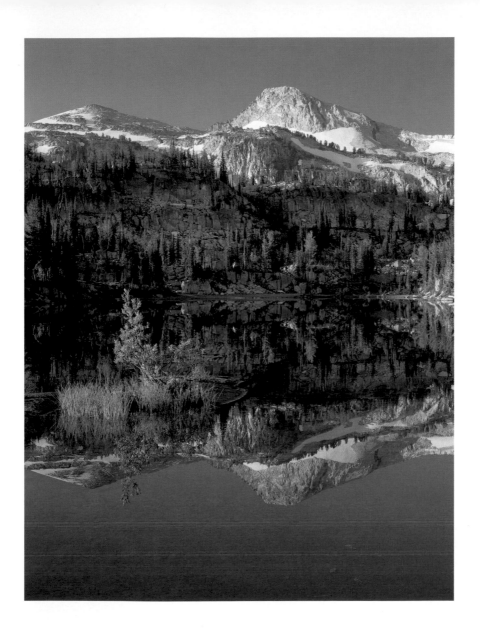

"The chess-board is the world, the pieces are the phenomena of the universe, the rules of the game are what we call the laws of Nature."

— T.H. Huxley, *A Liberal Education*

The Needles, Cannon Beach

Overleaf: Benson Lake, Columbia River Gorge National Scenic Area

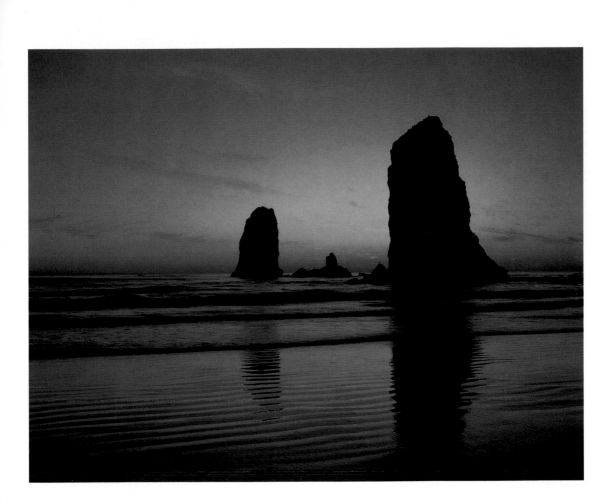

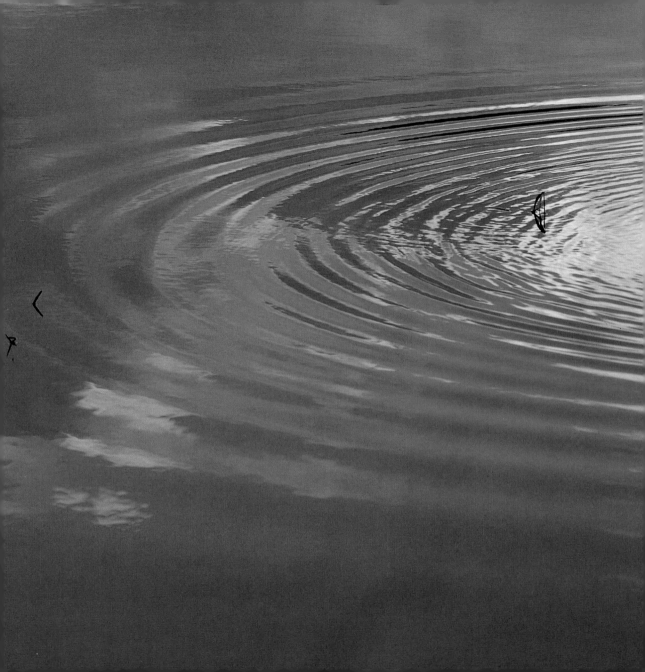

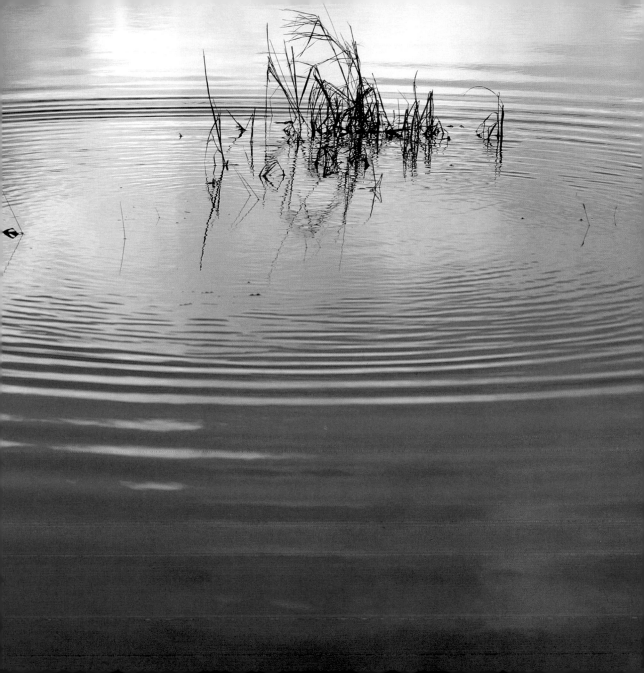

"The world turns softly
Not to spill its lakes and rivers,
The water is held in its arms
And the sky is held in the water.
What is water, That pours silver,
And can hold the sky?"

— Hilda Conkling, *Water*

Sparks Lake, Deschutes National Forest

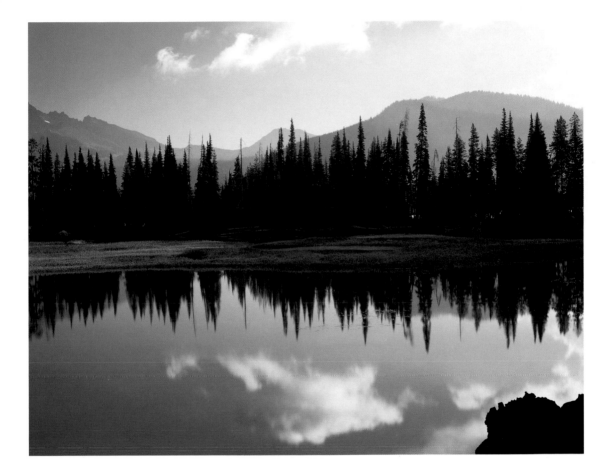

"Now I see the secret of the making of the best persons. It is to grow in the open air, and to eat and sleep with the earth."

— Walt Whitman, *Leaves of Grass*

Evening light on bulrush and cattails,
Rosyln Lake, Clackamas County

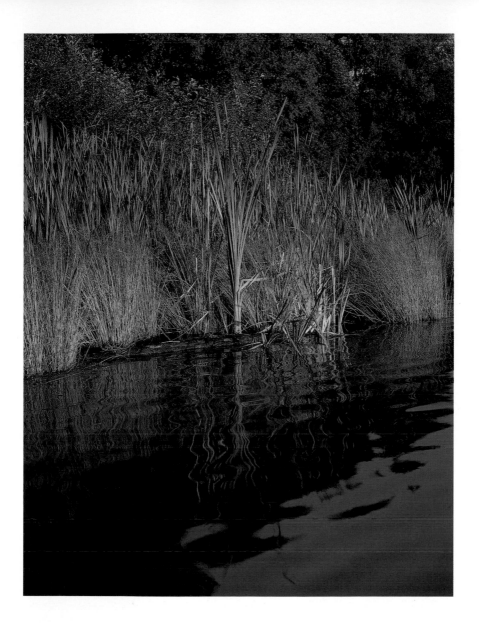

"A rock pile ceases to be a rock pile the moment
a single man contemplates it, bearing within him
the image of a cathedral."

— Antoine de Saint-Exupery, *Flight to Arras*

Alpine tarn below Mount Jefferson, Mount Jefferson Wilderness

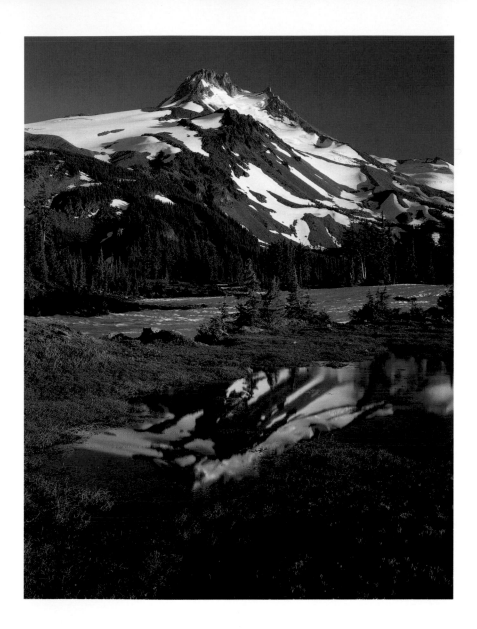

"For in and out, above, about, below,
T'is nothing but a Magic Shadow-show,
Played in a Box whose Candle is the Sun,
Round which we Phantom Figures come and go."

— Omar Khayyam, *Rubaiyat*

Fog rises above Douglas fir trees, Lost Lake,
Mount Hood National Forest

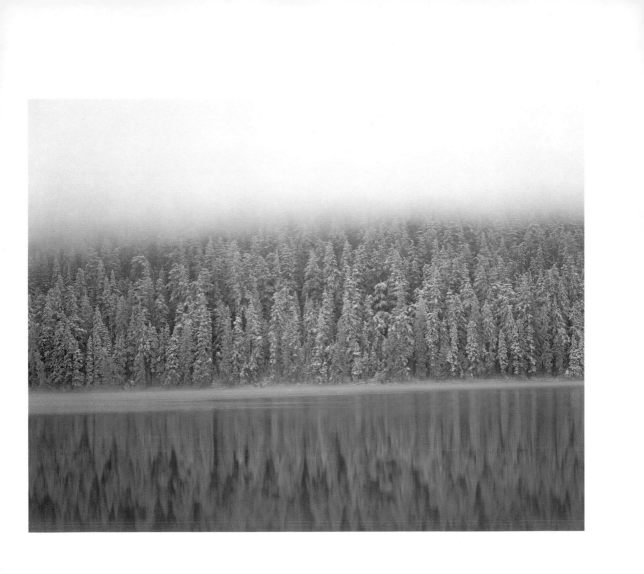

"The day, water, sun, moon, night — I do not have to purchase these things with money."

— Titus Maccius Plautus, *The Comedy of Asses*

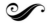

Heceta Head Lighthouse at sunset, Lane County

"We need the tonic of wildness…
We can never have enough of nature
We must be refreshed by the sight of inexhaustible vigor,
vast and titanic features…"

— Henry David Thoreau, *Walden*

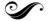

Mount Hood reflected in Trillium Lake, Mount Hood National Forest

"Nature is shy and noncommittal in a crowd.
To learn her secrets, visit her alone or
with a single friend, at most."

— Montaigne, *Essays III*

Knotweed along Big Creek, Siuslaw National Forest

Overleaf: Mount Bachelor, Deschutes National Forest

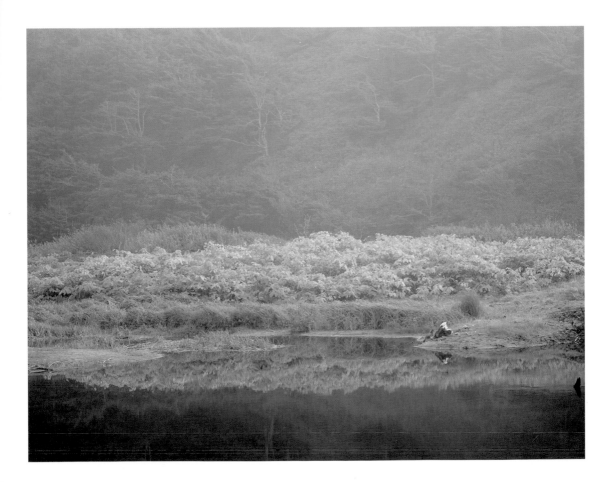

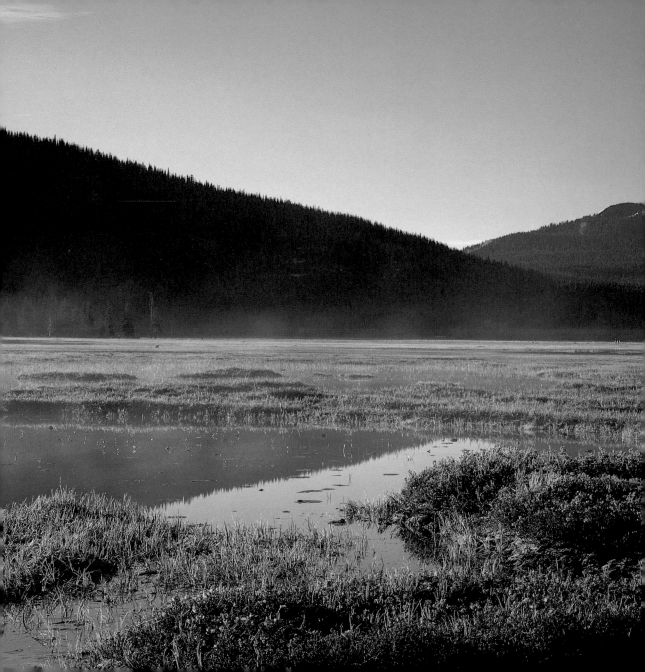

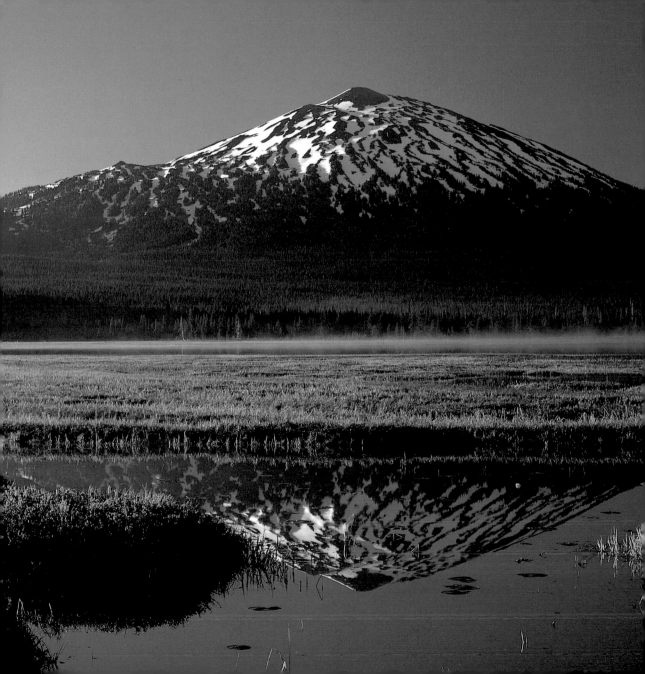

"Solitude…is essential to any depth of
meditation or of character; and solitude in the
presence of natural beauty and grandeur
is the cradle of thoughts and aspirations…"

— John Stuart Mill, *Principles of Political Economy*

Sunset from atop Neahkahnie Mountain, Tillamook County

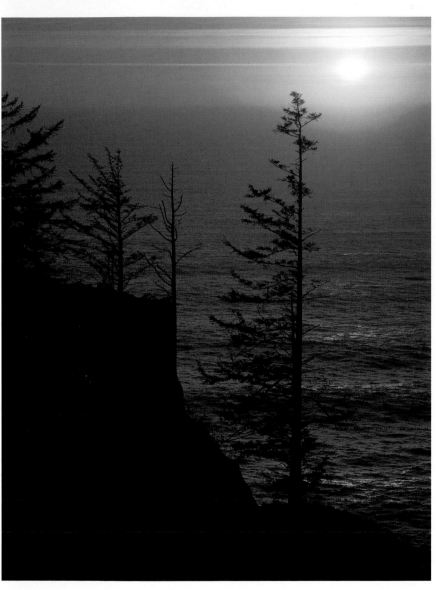

"To see clearly is poetry, prophecy,
and religion — all in one."

— John Ruskin, *Modern Painters*

Gunsight Mountain mirrored in Anthony Lake,
Wallowa-Whitman National Forest

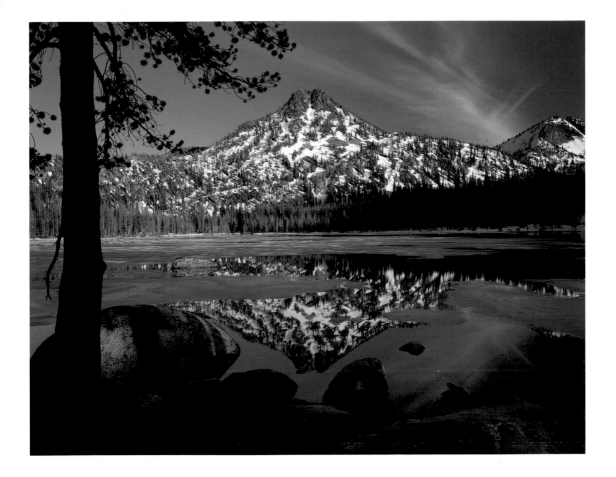

"And forget not that the earth delights to feel your bare feet and the winds long to play with your hair."

— Kahlil Gibran, *The Prophet*

Squaw Creek, Mount Hood National Forest

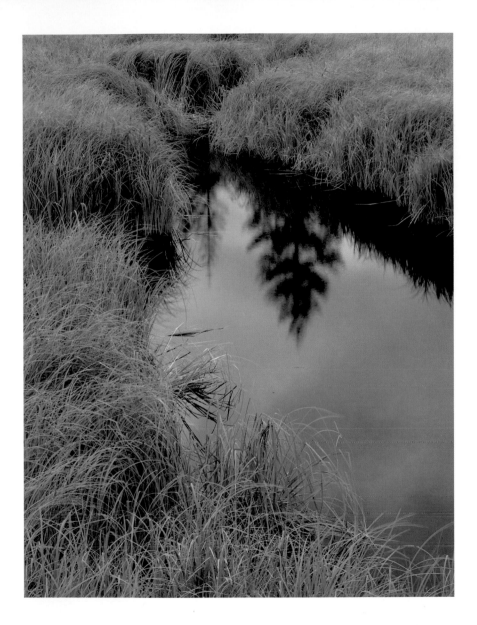

"Nature is an endless combination and repetition of a very few laws. She hums the old well-known air through innumerable variations."

— Ralph Waldo Emerson, *Essays*

Mount Hood at sunrise, from Multnomah County

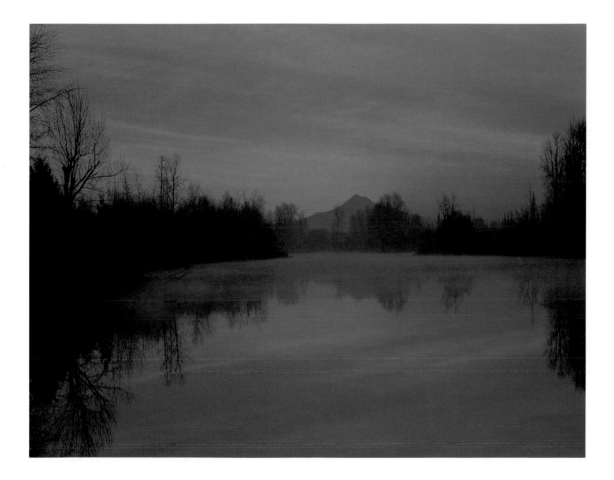

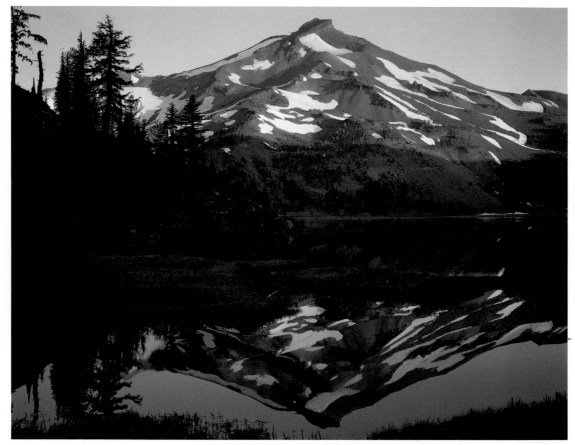

Early morning light on South Sister Mountain and Green Lake, Three Sisters Wilderness